Ruby and Foster

Made in the USA
Middletown, DE
10 December 2019